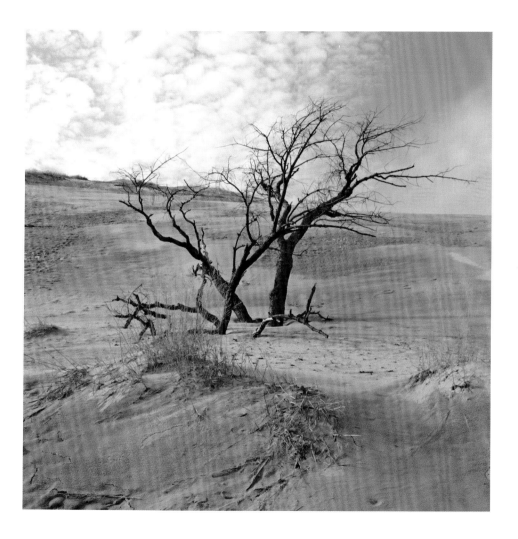

Sleeping Bear Dunes

National Lakeshore

photography by Terry W. Phipps

The University of Michigan Press
and
Petoskey Publishing

For
Steven E. Boyd

Copyright © Terry W. Phipps 2008
Margaret Rose Kelly, editor

Published in the United States of America by
The University of Michigan Press
and
The Petoskey Publishing Company

Manufactured in Canada
20011 20010 2009 2008 5 4 3 2 1
ISBN-10: 0-472-11676-2
ISBN-13: 978-0-472-11676-8
Library of Congress Cataloging-in-Publication Data on File

Signed Limited Edition Prints
t.phipps@greatlakestraveler.com

Other titles include:
Seasons of Sleeping Bear, Seasons of Little Traverse, Seasons of Mackinac
Sleeping Bear Dunes National Lakeshore, and *Mackinac Island*

Foreword

Sleeping Bear Dunes National Lakeshore was officially established as a National Park in 1970. Today, the park stretches across 35 miles of Lake Michigan's eastern coastline including the North and South Manitou islands. The park itself is young, yet the area preserved is alive with a long fantastic history of the shipping, logging, and farming industries that eagerly thrived in the 1800s as well as the history of the Ojibwa (or Chippewa) and Ottawa Native American cultures that occupied the land for several centuries. The name "Sleeping Bear" hails from a legend told by the Ojibwa tribe about a mother bear and her two young cubs and their flight from fiery Wisconsin.

While the park covers 35 miles of Northern Michigan's shoreline, the National Lakeshore has much more to offer than the beaches that grace the grand Lake Michigan. Vast acres of forests are protected under the National Park Service, providing habitat for the area's natural flora and fauna. Hiking trails cut through many of these forests, leading its visitors to beaches and, for some, to the top of a dune and spectacular view of Lake Michigan. The dunes themselves, once measuring up to 600 feet, now rush up from the shorelines at approximately 460 feet. It is argued that it includes the largest dune outside of the Sahara Desert.

The Sleeping Bear Dune Climb is perhaps one of the more popular attractions in the park today. At the top of the dune climb is a spectacular view of Glen Lake. While there is no immediate sign of Lake Michigan from the top, there is a three-and-a-half mile round trip trail available. Those who accept are rewarded by sightings of endangered and rare wildflowers and a breathtaking view of Lake Michigan.

Another popular attraction the park holds is the Pierce Stocking Scenic Drive, located near the Sleeping Bear Dune Climb. The drive is seven miles of paved road accessible by motor vehicle, bike, or on foot. Picnic areas and overlooks along the way take you to beautiful views of Glen Lakes, the Sleeping Bear Dunes, and Lake Michigan.

While not all of the towns within the national park are in operation, there are a few charming towns that still thrive to this day. The small town of Empire is a good place to start a visit to the lakeshore as it is home to the Philip A. Hart Visitors Center, a great place to learn more about the park's past and present. Glen Arbor, while not much bigger than Empire, is an alluring town filled with great dining and shopping opportunities after a day at the dune climb or an afternoon of swimming.

Nearly 40 years have passed since the establishment of the Sleeping Bear Dunes National Lakeshore. Continued preservation of this land is important historically, ecologically, and visually. It is a place of beauty and serenity…a place you will one day want to take your children and grandchildren, a place that will remain in your heart and your memory forever.

Makena E. Phipps

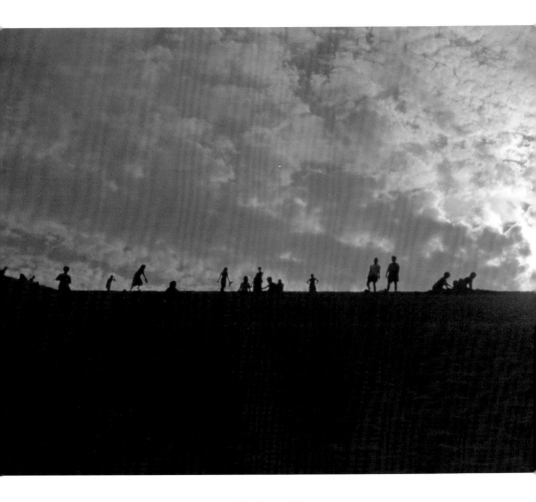

The Dune Climb

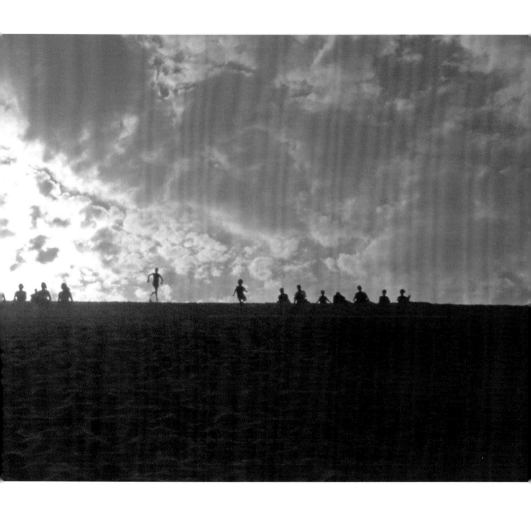

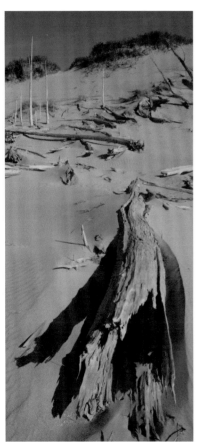
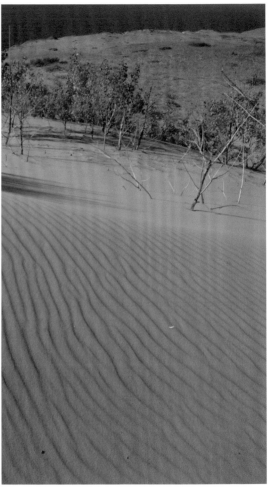

The Ghost Forest off Pierce Stocking Drive

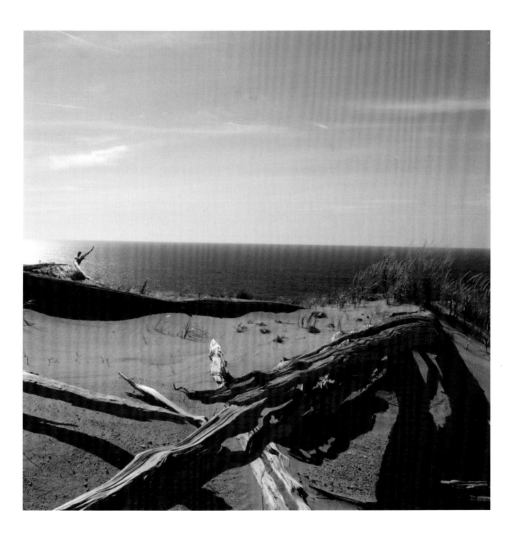

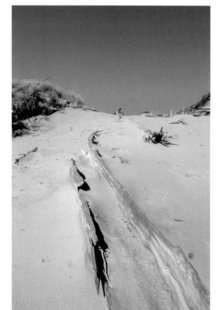

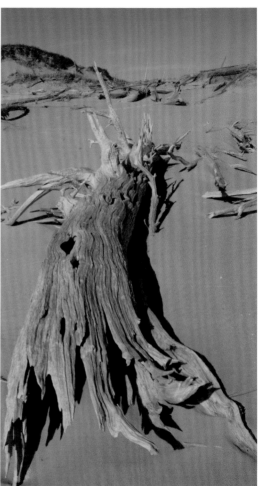

The Ghost Forest off Pierce Stocking Drive

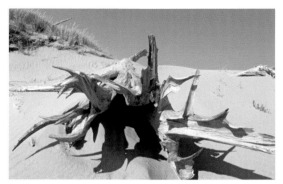

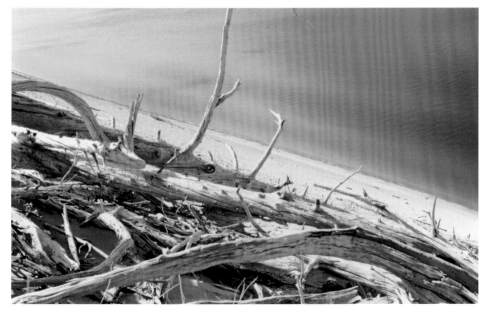

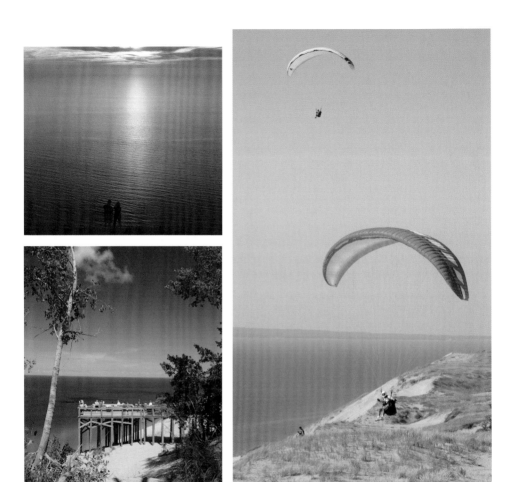

Lake Michigan Overlook along Pierce Stocking Drive

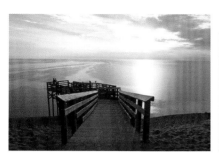

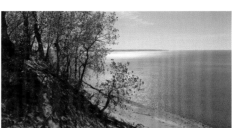

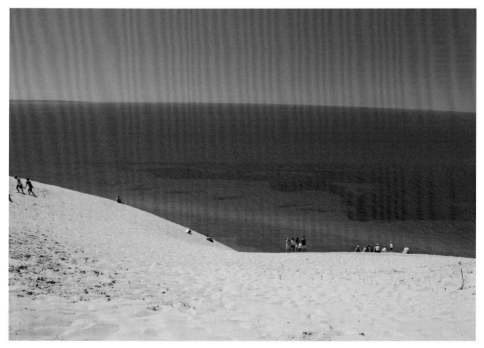

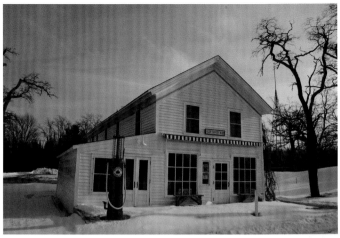

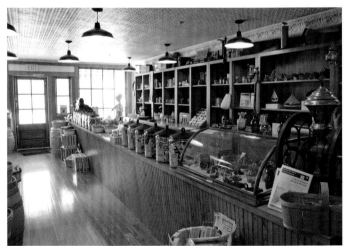

Glen Haven Coast Guard Station and General Store

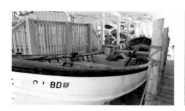
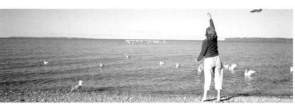
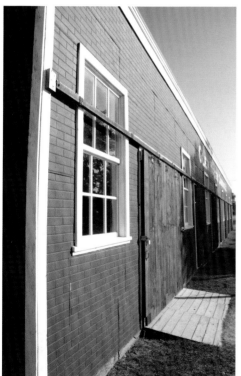
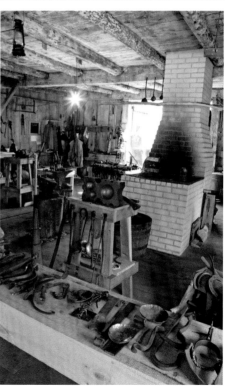

Cannery Beach and Blacksmith Shop

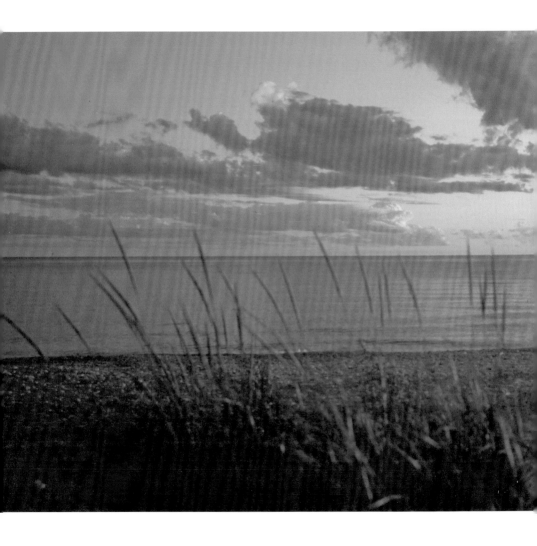

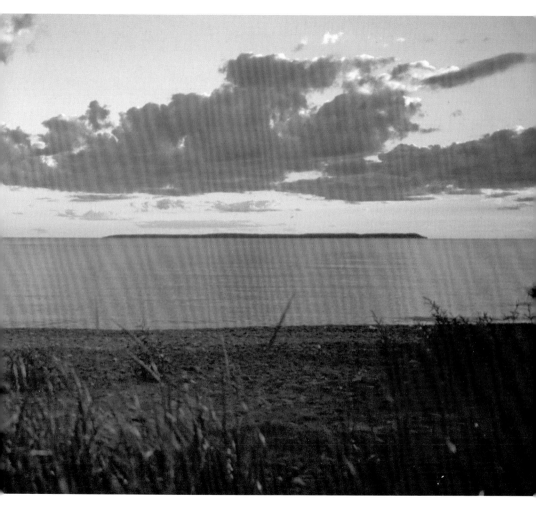

Good Harbor Bay and North Manitou Island

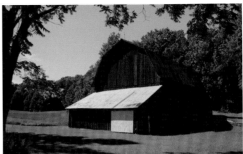

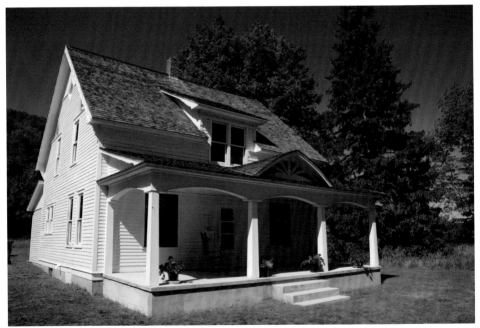

The Olsen Farm in Port Oneida

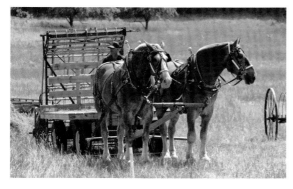
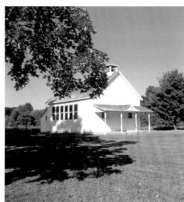
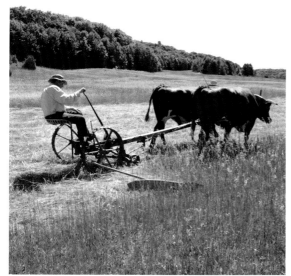
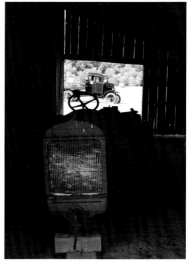

The Port Oneida Fair and school

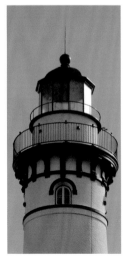

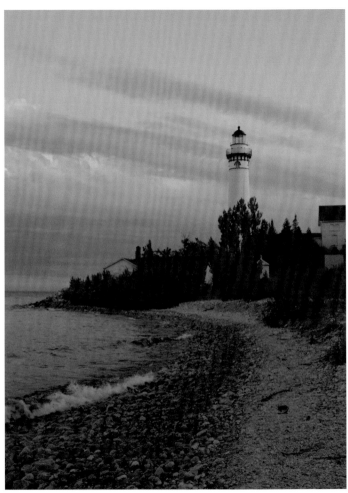

South Manitou Island Lighthouse

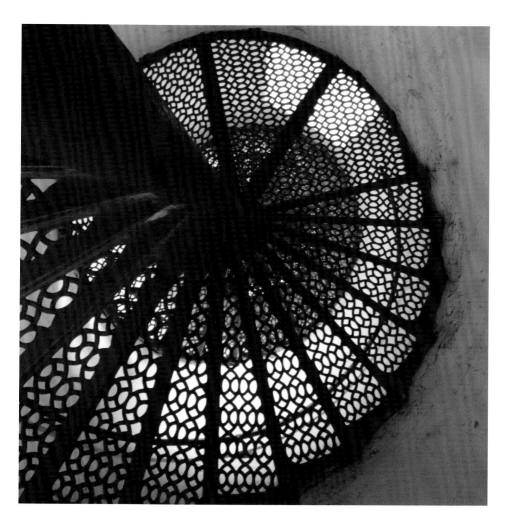

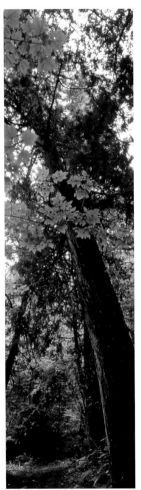
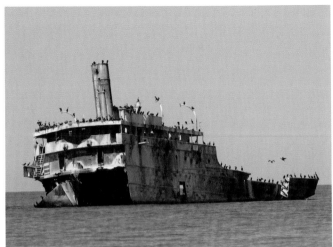
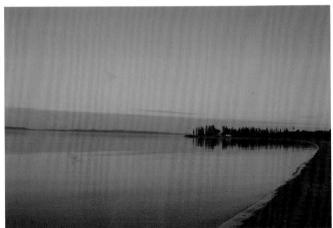

The Giant Cedar Forest, Francisco Morizan Wreck, and Crescent Bay

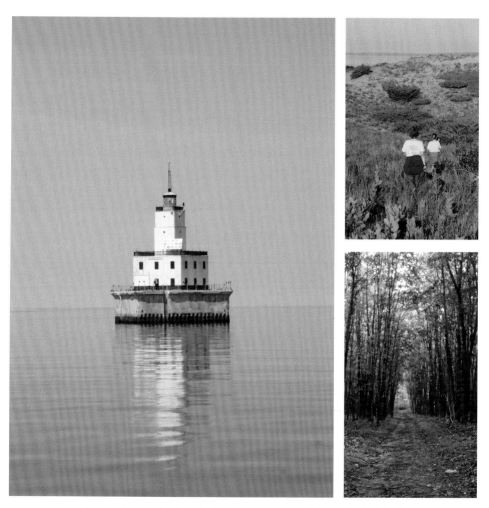

N. Manitou I. Shoal Light, Bone Boat Trail, and Giant Cedar Trail

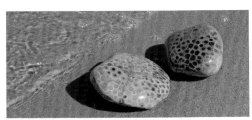

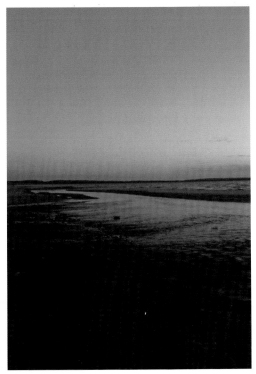

Aral at Esch Road

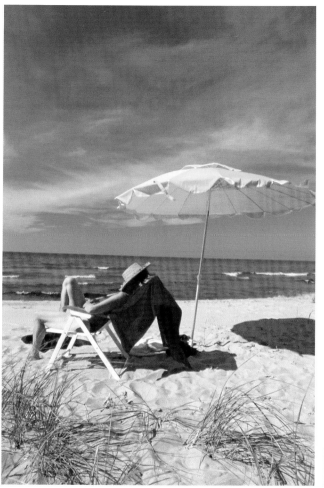

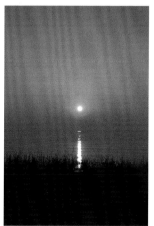

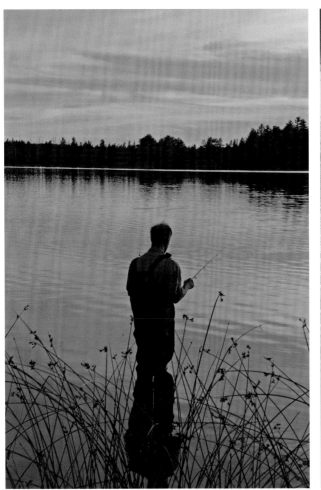

An evening on Loon Lake

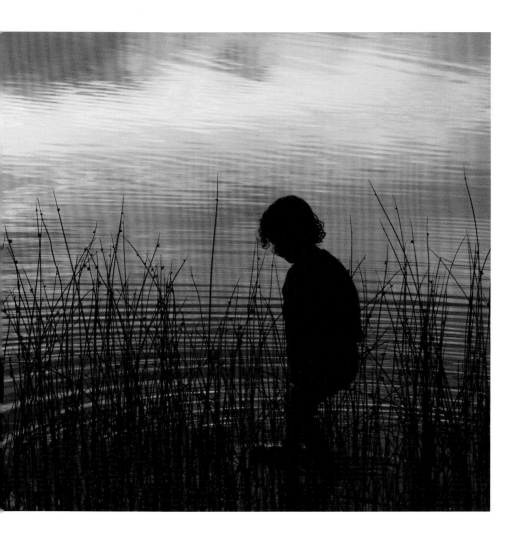

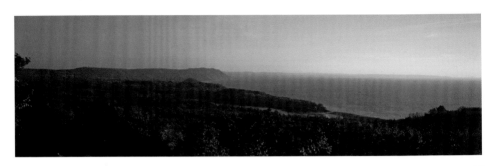

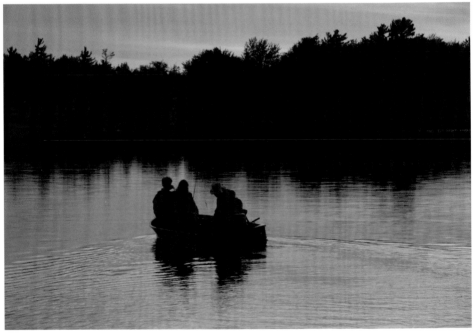

North Bar Lake, Lake Michigan, and Loon Lake

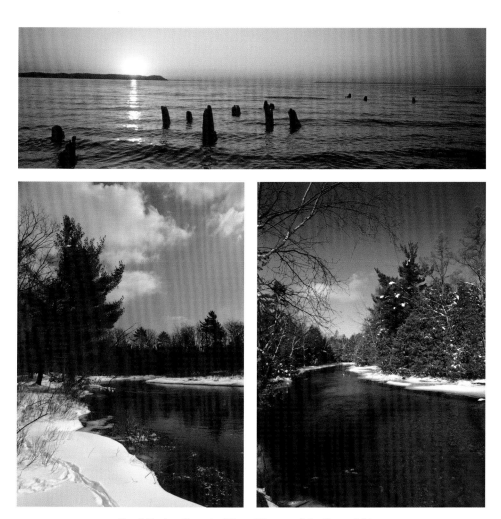

Good Harbor Bay, the Platte River, and the Crystal Rivers

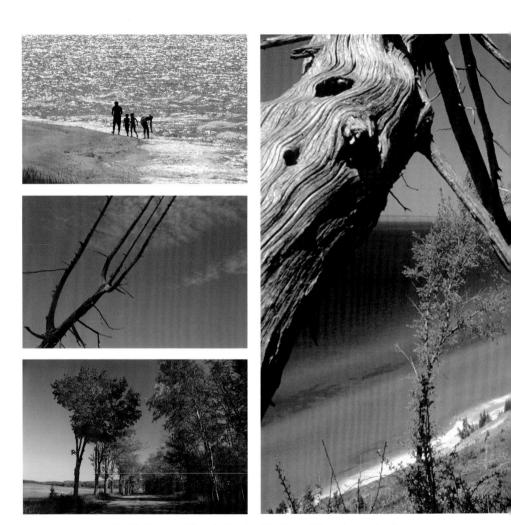

Bocklodge Trail Beach, Empire Bluffs, and Day Forest Road

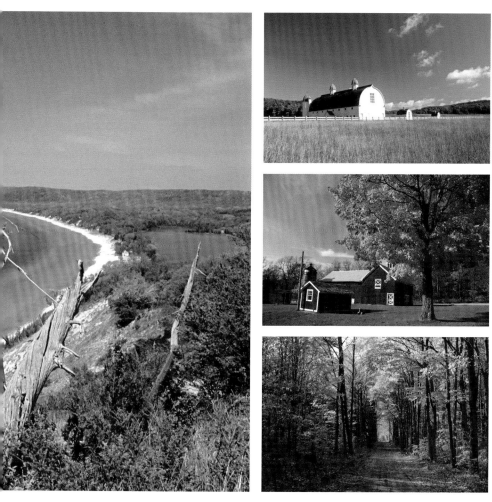

The D.H. Day Farm, Crouch Farm, and Burnham Road

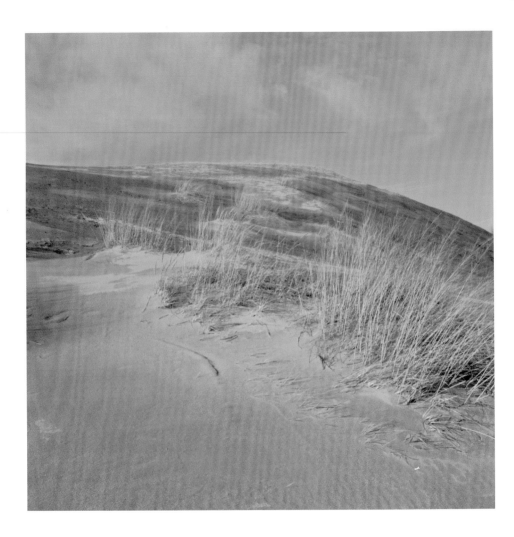